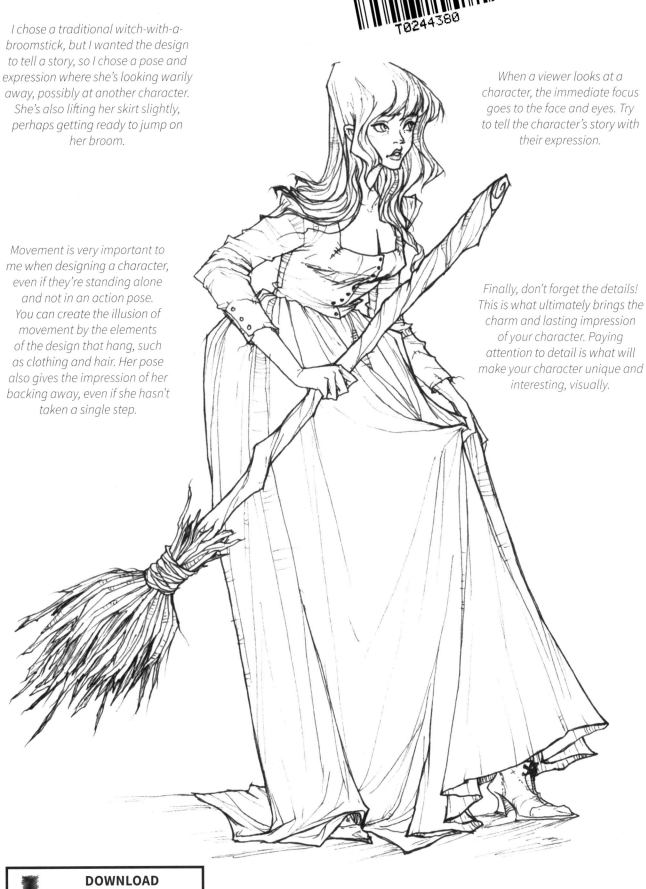

I chose a traditional witch-with-a-broomstick, but I wanted the design to tell a story, so I chose a pose and expression where she's looking warily away, possibly at another character. She's also lifting her skirt slightly, perhaps getting ready to jump on her broom.

When a viewer looks at a character, the immediate focus goes to the face and eyes. Try to tell the character's story with their expression.

Movement is very important to me when designing a character, even if they're standing alone and not in an action pose. You can create the illusion of movement by the elements of the design that hang, such as clothing and hair. Her pose also gives the impression of her backing away, even if she hasn't taken a single step.

Finally, don't forget the details! This is what ultimately brings the charm and lasting impression of your character. Paying attention to detail is what will make your character unique and interesting, visually.

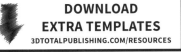

DOWNLOAD EXTRA TEMPLATES
3DTOTALPUBLISHING.COM/RESOURCES

© Abigail Larson

01 | Pose

Start by deciding the pose of the witch, you might need to play around with a few different angles and positions before settling down on one. To do this without having to erase your work over and over, start with a loose and very basic skeleton.

I like to start with the head. I know my character will have a ¾ turn, so I mark the head with crosshairs where the elements of the face will go. It doesn't have to be perfect, since this is our very loose base pose.

Next, decide how her spine will curve. This one is leaning a bit, so the curve will go back. But keep in mind, even if your character is standing straight, the spine is never perfectly vertical. Plan for the angle of the hips to help you decide how your character will stand. Again, it doesn't have to be perfect – but it's much easier to erase a single line than the entire torso of your character.

Add in ovals to show the chest and hips, and lines to mark where you want to draw the arms and legs. Some artists like to draw the shape of the ribcage and pelvis, which are great for characters who are nude or scantily clad – but my witch has a full gown on, so we can keep the skeleton loose for now.

Add in the shapes for hands and feet, choosing shapes that will reflect what your character will be doing with them. This witch will be holding a broom in one hand, and lifting her skirt with the other.

It might seem odd to even worry about the lower body because she's wearing a full-length skirt, but it helps to know where the clothing will puddle and drape later. It's also helpful to keep you from drawing the skirt too long or wide if you have the proper leg length already in place.

I chose triangles for the feet because she'll be wearing heeled boots. If your character is barefoot, or wearing lower shoes, you can use ovals or flat triangles – just keep in mind where the ball of the foot and the heel will fall in relation to the ground.

02 | Fleshing out your design

Now you can add some detail so she'll no longer be a skeleton. Starting with the head again, give shape to her face, showing her forehead, cheekbone, jaw, and other features. Mark with simple lines where her eyes, nose, and mouth will go, but don't focus on their details yet.

Flesh out her torso, arms, and neck. For a young female character, I like delicate features, like a thin neck and wrists, and spindly fingers. Keep the hands simple shapes using only lines at this stage.

Erase the skeleton, and continue to flesh out the arms and torso. You can start to add on the bulk of your character's clothing. Think about your character's dress and how it will fall while she holds it.

The hands can be a little tricky at this point, as you still don't have a solid reference for what she's holding yet, but keep the lines curved ready for the future items.

03 | Finer details

Give shape to her by adjusting the shape of her legs, the hem of her skirt, and adding some flesh to her fingers. Knowing where her hands grasp her skirt is essential, as it will dictate how the drape falls from that point.

Now focus on the hand holding the broom. You can add in the lines for where the broom will go, but remember you can have her holding her broom at any angle you like, or no broom at all – it's completely up to you. If she's holding a broom (or basket) keep her fingers curled, looking at your own hand for reference, noticing your knuckles and bones, and their movement.

Now add wrinkles and details to the skirt, showing that the dress is nipped in at the waist, follows the curve of her hips, then falls straight down to the ground. When designing your own costume, remember that clothing comes in virtually infinite styles. If you want a fuller, shorter skirt, remember the gravity will pull it straight down from the hips, unless there's a petticoat to give it volume. Play around with a few styles if you want.

I like to draw the legs even when my characters are fully clothed so I can make sure their height is believable and that the clothing is falling and swinging in the right areas. If your character is moving, show the swing of the skirt going away from the body. If it's windy, maybe the clothes are blowing behind them.

Now add in your broom – by this point try to have at least one hand to the point where you're happy with it. Add in some subtle details, like defining the chest and torso as well, so when you draw her bodice you'll know how it will wrap around her body.

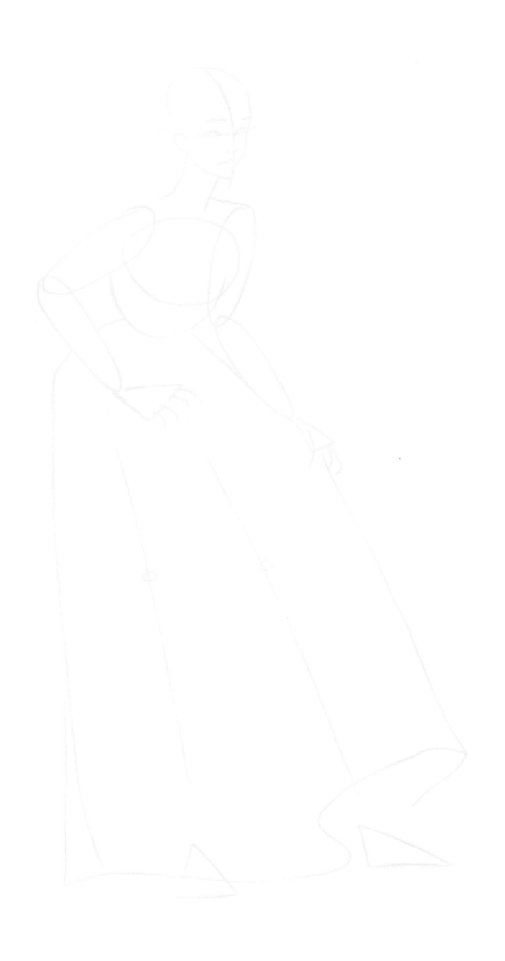

04 | Variations

You can now go through variations of hairstyle, facial features, clothing, props, and get everything honed down to the final sketch. This part will be a lot of trial-and-error, but it's also where you get to have the most fun with the design.

Continue to build up the silhouette of the character, including the clothing. You can start to erase stray guide lines that you no longer need, reducing your sketch to a very light gesture drawing.

Now revisit the face. There are so many directions you can go in when designing a face, but there are a few basic rules that will make your character look believable, while still being stylistic. Eyes, ears, noses, and hair will be among the first details a viewer will hone in on, so take some time to practice a few different kinds of features until you find a look you like.

Your witch can be older (more wrinkles around the eyes, nose, and mouth, higher cheekbones) or younger (rounder features, large eyes, full lips) or anything in between! Hairstyles vary as well, but remember to keep in mind both the volume of the hair, and the movement. Its swing should match the swing of her clothing, unless she's perfectly still.

05 | Final drawing

I like to start on a fresh piece of paper when I move on to my final drawing because of how messy my final sketches tend to be, but if you're very careful with erasing and keeping your working lines light, you can move straight on to the final lines. Be careful to maintain only the lines that define the form the best. My final sketches are always, well, sketchy. I build up a lot of lines until I find the right placement, and it can end up looking very messy! Build up the form of your witch on top of my template, but try to imagine your own variations on her outfit, props, facial expression, and hair. She's a witch, after all, so make her as magical as you want!

© Abigail Larson

How to draw an elf

Learn to draw an elf in three stages.

In this chapter, we are going to look at the way I start a drawing – covering gesture, construction and variations in form. To give your elf the most authentic and three-dimensional appearance, you need to be familiar with human anatomy. Elves, like humans, come in all shapes and sizes, so play around and have fun!

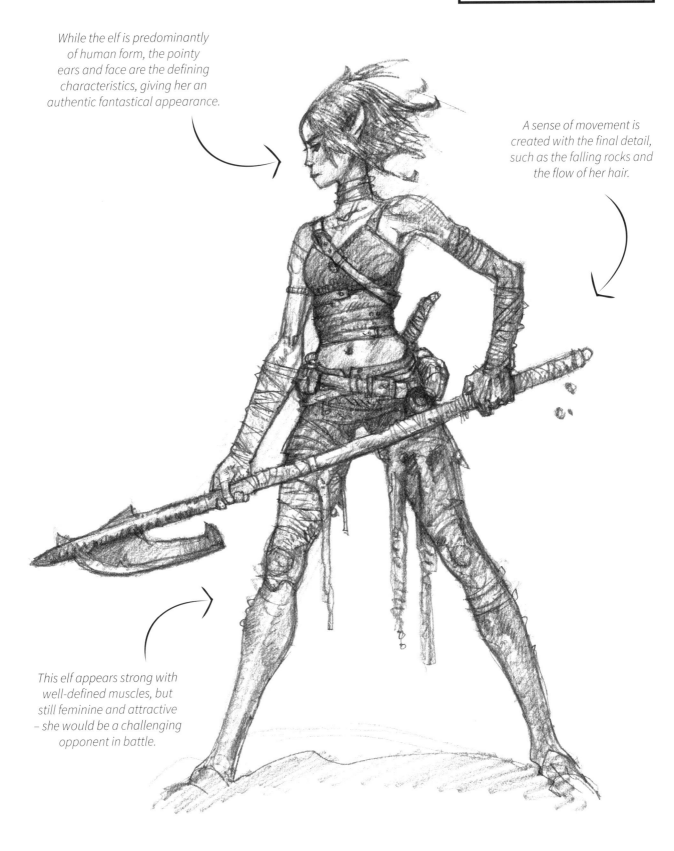

While the elf is predominantly of human form, the pointy ears and face are the defining characteristics, giving her an authentic fantastical appearance.

A sense of movement is created with the final detail, such as the falling rocks and the flow of her hair.

This elf appears strong with well-defined muscles, but still feminine and attractive – she would be a challenging opponent in battle.

© Larry MacDougall

01 | Gesture

Start your drawing with a loose, comfortable grip on your pencil. Move your pencil slowly around to create the general impression of the pose you want to draw. Do this until you like what starts to emerge, not worrying about any details for now.

You can use this process if you are either drawing from life or if you are making something up as we are here. The important thing to remember is to stay loose and relaxed. I find it works best for me if I leave my pencil on the paper and draw with one long, single line, letting it move over the form and travel back and forth over the paper. Keep the line moving and flowing – this allows you to draw with a single purpose. As soon as you take your pencil off the page you are switching to a new thought and this will divert you from your original intention – one line one thought.

You can try many different gestures and body poses before settling on the one you will take through to its final state.

02 | Construction

The body is, of course, made up of many parts, so you need to visualise each section as a separate unit when drawing them. This includes the head, the torso or rib cage, the pelvis, and the arms and legs. Figure construction is very complex, but for now just start off with the basic forms.

Draw a ball with a mask on the front for the head and cylinders for the arms and legs. If you simplify the parts of the body into these simple components, it is easier to imagine what they will look like. It requires a lot of practice, but your drawings and posing will be much easier to create.

03 | Adding detail

Add tone to the drawing to bring it to life – the shadows make it realistic and suggest elements of color.

Get familiar with the basics of human anatomy, if you're not already, then flesh out your character. Flesh on the body goes over the basic construction of the figure, so you want the figures you draw to look convincing and three-dimensional – it will help if your initial drawings are simple and solid structures.

You can play around with your character's clothes, hair and accessories, but keep the fundamental characteristics of your elf – such as the elfin face and ears.

04 | Variations

Alter the proportions and change the sizes of the various structural elements to make different body shapes for your elf – big hips, small chest; muscly; athletic, and so on. You can create a large cast of characters, anything goes!

05 | Final drawing

Have fun with your drawings; your character could be grotesque, or beautiful; playing a part in a tragedy or perhaps a comedy. Create the story with the use of additional details, the pose, expression and use of tone.

© Larry MacDougall

Troll

Use these techniques to create your own stylized troll.

In this tutorial, you'll learn techniques for designing a troll; how to refine a sketch, and how to use the same fundamentals as you would use for drawing a human to create an exaggerated form for a creature. I'll walk you through the basics of form, and how to use simple shapes to build up your character. Then I'll show you how to connect the shapes to refine your design, and how to add details to bring your character to life.

Though trolls can be almost humanlike in appearance, I wanted to give him distinctly creature-like features - like a protruding brow, fangs, and a horn.

I chose to make my troll very bulky and top-heavy. Of course, trolls, like humans, come in every size and shape, so you have lots of room for creativity with this creature. His weight is in his upper body, so, like a gorilla, he makes use of his long forearms by using them to walk.

I want to convey a subtle sense of movement, even though this is a still image. I achieve this by choosing a pose that suggests my troll is walking, or turning.

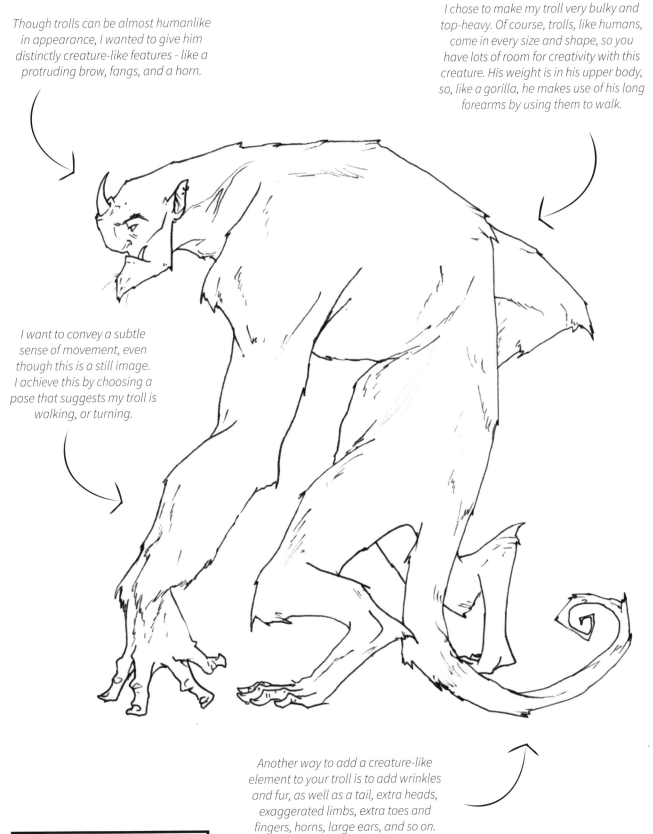

Another way to add a creature-like element to your troll is to add wrinkles and fur, as well as a tail, extra heads, exaggerated limbs, extra toes and fingers, horns, large ears, and so on.

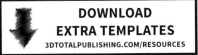

© Abigail Larson

01 | Pose

First, you need to map out the troll's pose. Start by drawing a very light, rough skeletal form to guide you later when you add bulk to the creature. Keep your pencil loose in your hand, and light on the paper as you will erase these guides later.

Start by drawing a round or oval head, then add in a jaw line. This troll will mostly be in profile – draw a flat line to show you where to draw the brow ridge and nose.

Next, decide how the spine will curve. This one is hunched over, resting most of his weight on one arm, so start with a broad curve.

Add simple circles to show where to place the chest and hips. Knowing this placement will help you connect where the limbs will come from.

Add lines for the limbs. I use circles to show me where his joints are, but you can keep them as simple lines for now. You can give trolls an added "monster" quality by making their legs double-jointed. Use a triangle for the hand because his fingers will be splayed outward. And this will guide you later.

His right arm won't be showing very much, but it's a good habit to practice drawing as though it will be 3D, to give you a better understanding of the form.

02 | Basic shapes

In this exercise we'll cover the basics of fleshing out your troll. You don't need to add muscle at this stage, just build on the skeleton to help give him a form. Use basic shapes to help see what he'll look like.

Now, add more shapes to show his stomach and legs. These can be as thin or wide as you like.

Erasing the skeleton finally, continue to flesh out the arms and legs, then you can focus on smaller areas such as the hands and feet. Again, this is a creature who can have large, exaggerated appendages – bulky, knobbly, whatever you like. Still just use simple shapes to show you where to draw those details later.

Now you can focus on his face. I love giving my creatures a pronounced under-bite and a protruding nose bridge, or heavy brow. Map out those areas with smaller shapes and guide lines.

03 | Adding lines

Give some shape to your troll by marking with sharp lines where his muscles are.

Continue to add in details on the limbs, paying attention to the shape of his legs, tail, and arms. Draw lines for his stomach, keeping in mind that he's hunched over, so it will pouch out a little bit (or a lot, if you're drawing a fat troll!).

Add in some joints for the fingers and toes, but while there aren't many rules when designing a creature, he should still look somewhat believable. Give him as many fingers and toes as you like, but make sure you show bone structure underneath.

04 | Finer details and variations

Continue to build up the silhouette of the character. You can start to erase stray guide lines that you no longer need, reducing your sketch to a very light gesture drawing.

Revisit the face – there are so many directions to go in when designing a troll's face – he can look angry, sad, happy, but the features themselves can be as large or small as you want. Try a long nose, smaller jaw, open mouth, big ears, anything you want.

Move on to the details of his fingers and toes. I like to give my trolls knobbly joints to show age and wear, and to give them a quirky look. Humans have two joints in their fingers, but you can give the troll single joints to give him flat, stubby fingers. In contrast, his toes are long and spindly.

Trolls are typically hairy, but you can choose the length of your fur. I imagine they'd be rather messy, so I have my troll's fur sticking out at the major curves and joints. Longer hair will hang down off the body. Use short pencil strokes to give the impression of fur.

05 | Final sketches

Final sketches can end up looking rough or messy, but take a moment to have a break, step away from your drawing, then come back to it with fresh eyes. This will help you see any mistakes you might have made, or, simply notice areas you want to change before you clean up your linework.

Try to imagine your own variations on his form as well – maybe give him a bigger nose, a deeper brow ridge, a longer face, and so on. Fantasy creature design gives you freedom to make a creature as weird as you want!

Faun

Learn to use building blocks to create a character design.

Designing and drawing a character containing human and animal body parts is a tricky task, as you need to be able to grasp different sorts of anatomy. In this workshop you will learn how to build up your design from simple gestural drawings to rendered and engaging characters.

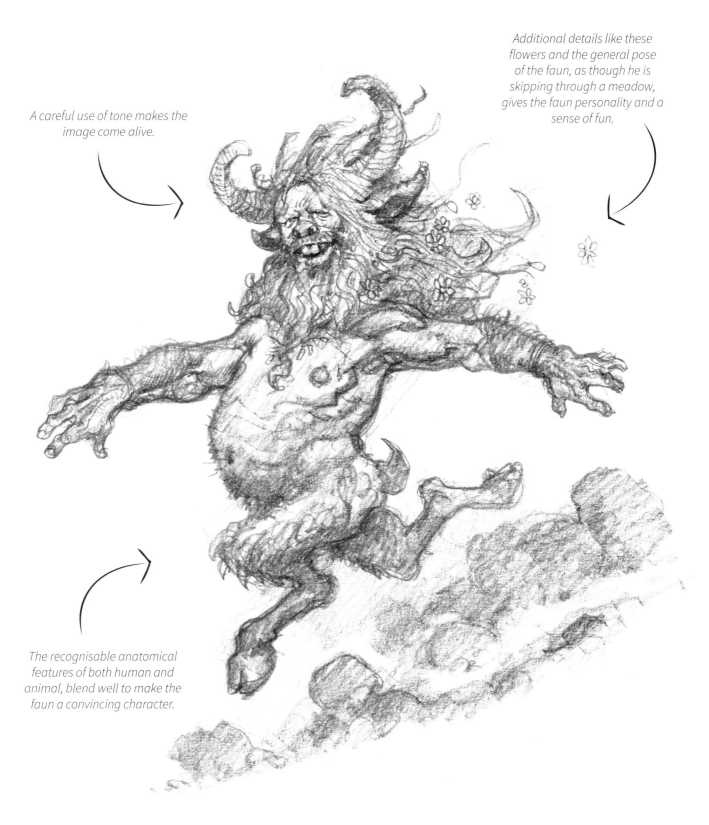

A careful use of tone makes the image come alive.

Additional details like these flowers and the general pose of the faun, as though he is skipping through a meadow, gives the faun personality and a sense of fun.

The recognisable anatomical features of both human and animal, blend well to make the faun a convincing character.

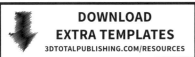

© Larry MacDougall

01 | Gesture

I believe the best way to start a sketch is with a gesture drawing, especially if you are not certain what to draw.

Try several different gestures to see what happens. The more you do, you will find the better they get, as you are warming up and starting to flow.

Gesture drawing works best when you are relaxed and have a loose, comfortable grip on your pencil. Move your pencil slowly around to create the general impression of the pose you want to draw. There is no need for details at this point, you just need to find the pose and with some loose, fluid lines let your pencil roam over the paper until you like what starts to emerge.

02 | Construction

This stage naturally follows on from the gesture stage – many experienced artists will do the construction stage and gesture stage at the same time, but for now, separate these two steps.

The head is skull shaped and seen as a ball with a mask on the front. The arms and legs are cylinders. We try to simplify the parts of the body down into these simple components so that it is easier to imagine them and draw them. It makes drawing and posing the figure much simpler but it requires a lot of practice to learn how to do it.

Visualize the body in its separate units; the head, the torso or rib cage, the pelvis, and the arms and legs. Figure construction is a very complex topic and we don't have room to go into it in depth here but we can take a quick peek at it. In my drawings, you can see that I am thinking of the rib cage as an egg shape and the pelvis as a soup bowl with a bite taken out of the front.

03 | Adding tone and detail

Now that we have a gesture down and have worked out the basic construction of the figure it is time to flesh it out and add tone. The tone will bring this drawing to life by not only creating shadows but also indicating local colour as in his beard and hair. Skilful use of tone will make your drawing come alive.

The first thing we must do is put some flesh on the bones. Knowing some anatomy will help you a lot when you are drawing people.

You want the figures you draw to look convincing and three-dimensional, so, make sure your drawings are working over a simple and solid structure or construction.

04 | Variations

In this final stage, you can invent an endless variety of figure variations by manipulating the first three steps. If you alter the proportions and change the sizes of the various structural elements you can make any body shape you can imagine – large torso, small pelvis or long arms and short legs, and so on. This will let you populate your drawing with a varied and fascinating cast of characters from the grotesque to the beautiful, and from the tragic to the comic.

05 | Final drawing

Experiment with different designs. Drawing these variations is at the heart of what most commercial artists do. Concept artists, character designers, illustrators, game artists all make their livings by coming up with new and inventive variations. We learn the first three steps so that we can have fun and explore with this final step. Good luck and draw something cool!

© Larry MacDougall

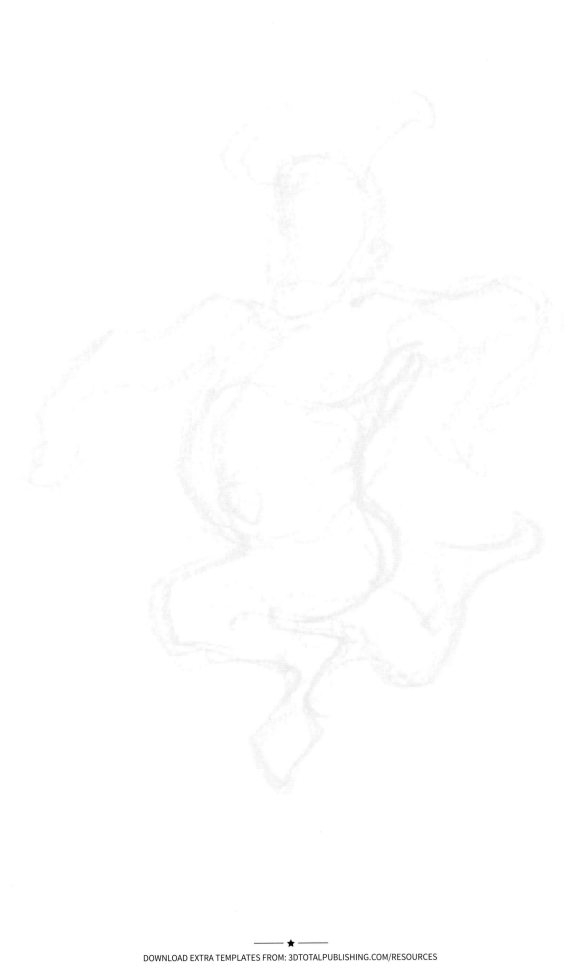

The **Sketch Workshop** is a complete sketching solution for beginners and hobbyists alike. It is an innovative and fun way for people of all ages to find the inspiration to pick up a pencil – and draw! We've created a number of guides that cover popular topics such as **mechs & weapons**, **fantasy characters**, **landscapes**, **and future concepts**, all loaded into ready-to-go sketch workbooks.

To complete your Sketch Workshop collection, be sure to check out all four workbooks in this series.

Visit **www.3dtotal.com/shop** for more information

FANTASY CHARACTERS FUTURE CONCEPTS LANDSCAPES MECHS & WEAPONS

3dtotal Publishing
Correspondence: publishing@3dtotal.com
Website: www.3dtotalpublishing.com

First published in the United Kingdom, 2017, by 3dtotal Publishing.
3dtotal.com Ltd, 29 Foregate Street, Worcester WR1 1DS, United Kingdom.

Soft cover ISBN: 9781909414808

Printing and binding: Everbest Printing (China)
www.everbest.com

Visit www.3dtotalpublishing.com for a complete list of available book titles.

Abigail Larson | www.abigaillarson.com
Witch | Troll

Larry MacDougall | www.mythwood.blogspot.co.uk
Elf | Faun

MIX
Paper from responsible sources
FSC® C124385